Hidden Pictures

숨겨진 장면들

Epilogue

Many fleeting moments that

we find and lose as we journey through life.

I promise not to forget what I love.

May I occasionally rediscover and cherish

the moments I hold dear

amid the countless memories that

ebb and flow, making them shine brightly.

Summer 2023,

Heejin Kim and Saerom Park

에필로그

살아가면서 찾았다가 잃어버리는

수 많은 반짝이는 순간들.

좋아하는 것을 잊지 말아야지, 다짐합니다.

일렁이며 쌓여가는 수많은 기억 속에

내가 좋아하는 것, 좋아하는 순간들을

이따금 다시 발견하고 상기하여

빛나게 만드는 경험이 되기를 바랍니다.

2023년 여름,

김희진 박새롬

바다

하늘보다는 깊은 바닷속을 꿈꾼다.
막연한 생각이지만, 하늘을 나는 것은 춥고 외로울 것 같다.
내 꿈속의 바다는 적당한 온도와 압력으로 나를 눌러주고,
반쯤 투과한 햇살에 유영하는 물고기들이 반짝인다.

가장 고요하지만 가장 살아있는 곳.
마음에 품은 바닷속에서 안온한 탐험을 해 본다.
오늘의 바다는 무슨 색일까.

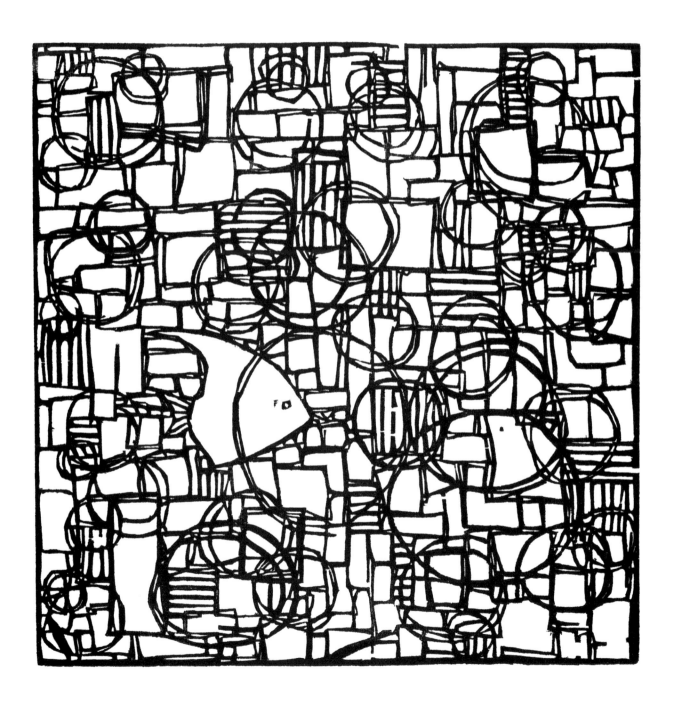

The Sea

I dream of the deep ocean rather than the sky.
It may sound vague, but flying in the sky
seems cold and lonely to me.
In my dreams, the sea surrounds me with just the
right temperature and pressure, and the shimmering fish
swim in the partially permeated sunlight.

The most tranquil yet the most vibrant place.
I embark on a peaceful exploration
within the depths of my cherished sea.
I wonder what color the sea will be today.

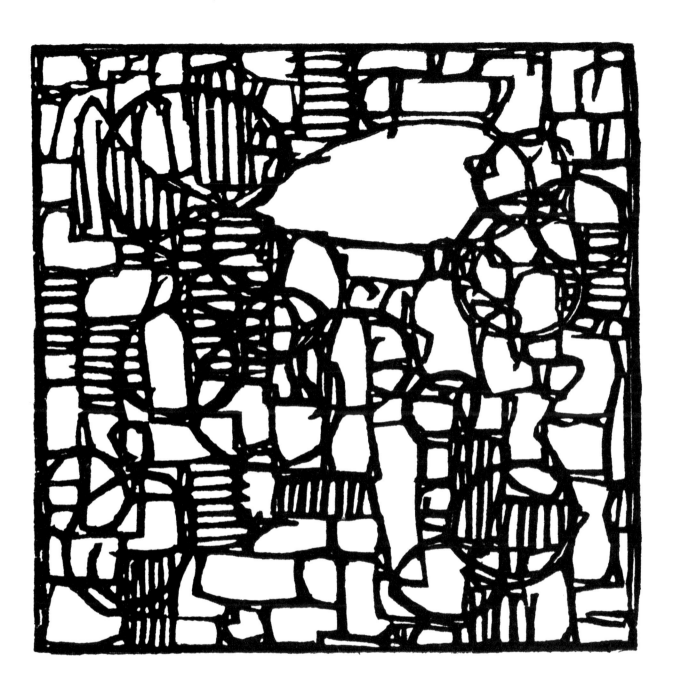

Beach

My dream is a life peacefully lying by the shore.

It would be even better with a gentle melody

and fragrant drinks. I'd wear the lightest of clothes,

perhaps even go barefoot, and if heaven

exists, it might just look like that.

So, I find myself at the beach time and time again.

I lie there, listening to the sound of the waves,

for a while. As I let go of all tension and

float on the water's surface like a leaf, my mind

clears, and I become one with the sea. Standing,

feeling the waves burying my feet in the sand,

I become like sturdy seaweed,

merging with the beach.

To breathe in the sweet sea breeze with

my whole being and walk leisurely,

I must work hard today, once again.

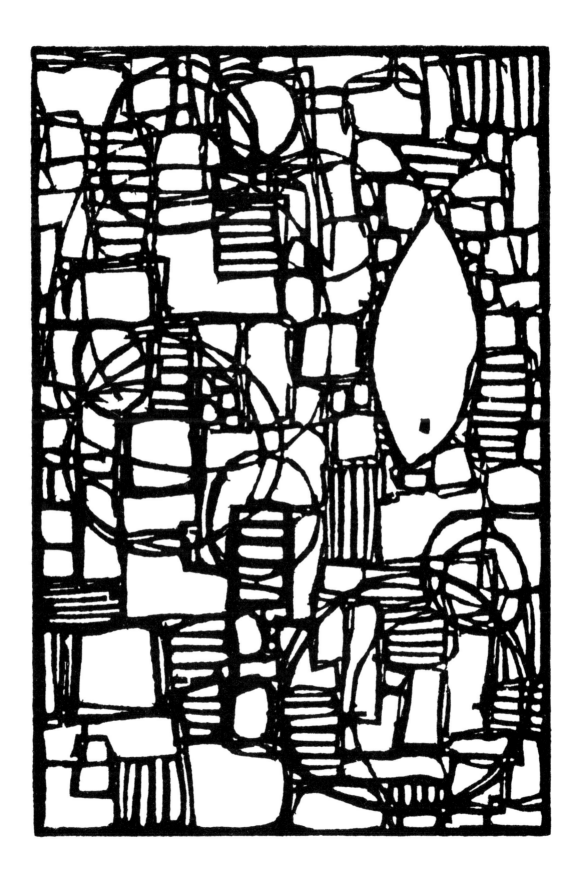

해변

내 꿈은 물가에 평화로이 누워있는 삶이다.

선선한 음악과 향긋한 음료가 있으면 더 좋겠지.

옷은 최대한 가벼이 걸치고 신발도 신지 않은 채,

천국이 있다면 아마 그런 모습일 것이다.

그래서 나는 자꾸 바다에 간다.

파도 소리를 들으며 한참 누워있다 온다.

온몸에 힘을 쭉 빼고 일렁이는 물 위에

나뭇잎처럼 떠 있자면

머릿속이 깨끗이 비워지고, 바다와 하나가 된다.

모래 속에 발을 묻고

드나드는 파도를 느끼며 서 있자면

뿌리 단단한 해초가 되어, 해변과 하나가 된다.

달큰한 바닷바람을 온몸으로 들이마시며

한가로이 걷기 위해,

오늘도 열심히 일해야지.

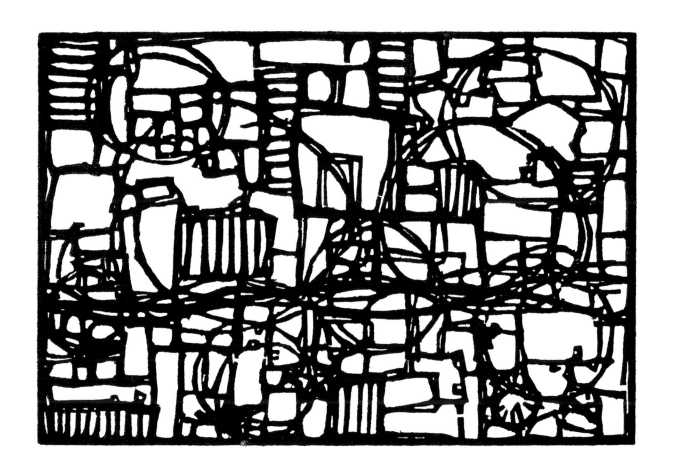

과일

철마다 돌아오는 싱그러운 향과 달콤함을 맛보는 것은

팍팍한 도시 생활 속의 작은 기쁨이다.

봄에는 딸기, 여름엔 수박.

늦여름 무화과는 꼭 먹어야지.

국산 과일이 마땅찮을 때는 체리나 오렌지, 망고를 산다.

깨끗이 씻어 놓은 색 고운 과일을 마주할 때면

본능적인 기쁨이 유전자 깊숙한 곳에서 우러나온다.

자연이 주는 선물을 발견한 기쁨 한 알을 깨물며

순간이나마 나는 자연의 일부가 된다.

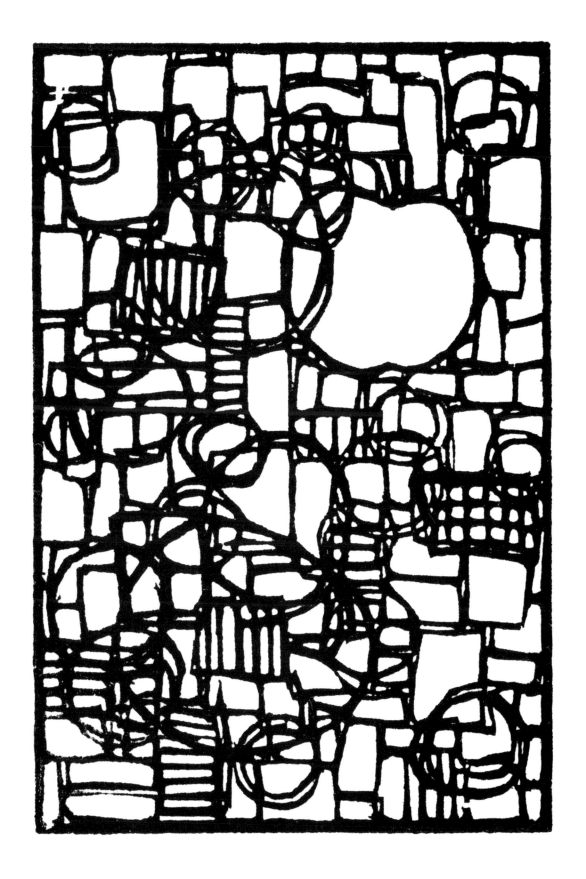

Fruit

Tasting the refreshing aroma and sweetness

that comes with each season is a small joy

amidst the bustling city life.

In spring, it's strawberries; in summer, watermelons.

I must have figs in late summer.

When domestic fruits are not readily available,

I opt for cherries, oranges, or mangoes.

The innate delight surges from the depths of my genes

when I come face to face with the brightly colored,

meticulously washed fruit.

Biting into the happiness of discovering nature's gifts,

even for a moment, I become a part of nature.

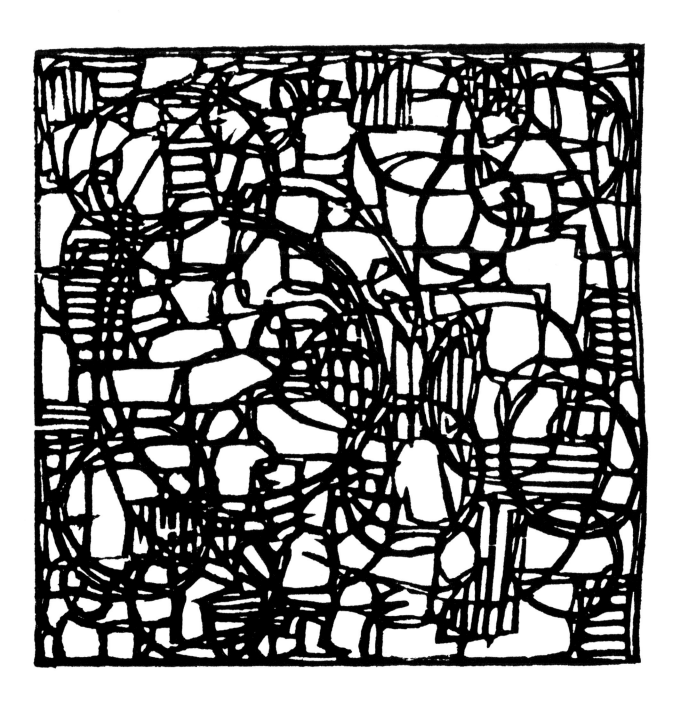

술

내 인생 첫 와인은 로마의 트레비 분수 앞에서 마신 연보라색 딱지가 붙은

이탈리아 와인이었다. 노점에서 흥정하여 만 원-이만 원 정도에 샀던가.

분수 앞에 앉아 일행들과 병째 돌려가며 마신 추억에,

한동안은 이탈리아 와인을 많이 마셨다.

두 번째로 마음에 든 와인은 회사 막내 시절, 팀장님이 좋아하시던 호주 와인이었다.

싱그러운 이슬을 머금은 정원의 향이라고 했던가.

퇴근 후 팀과 함께 가로수길 테라스 자리에 앉아 리코타 치즈와 꿀에 절인 사과를

함께 먹었다. 나에겐 왠지 어른의 맛이었던 화이트 와인. 여름이 되면 생각이 난다.

마지막으로 좋아했던 와인은 세련되고 깔끔한 맛의 나파밸리 와인이다.

30대에 막 접어든 내가 바라던 삶과 닮아 있었달까.

와이너리에서 시음에 심취해 비행기를 놓친 추억이 있다.

이제 더 이상은 와인을 사랑할 수 없는 것이,

점점 더 알코올 분해 능력이 떨어져 술을 즐길 수 없는 수준이 되었기 때문이다.

함께 마실 사람이 많이 있을 때에만 가끔 병 와인을 딴다.

중년에 멋진 술을 즐기는 삶이 나에겐 허락되지 않았지만

향과 맛과 분위기가 새겨진 한 잔에 담긴 순간들을 생생히 떠 올려 본다.

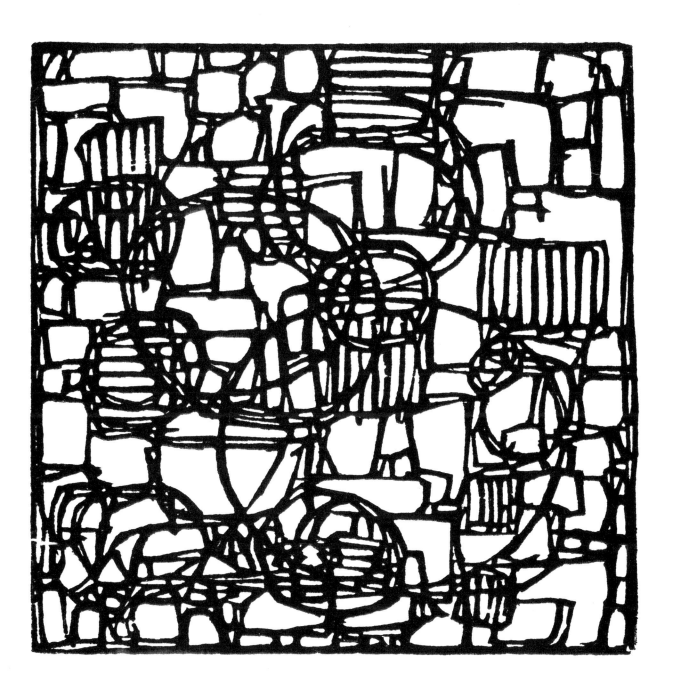

Alcohol

My first taste of wine in my life was an Italian wine with a violet label,
sipped in front of the Trevi Fountain in Rome. I haggled with a street vendor and
bought it for around 10 dollars, if I recall correctly. Sitting by the fountain,
we took turns passing the bottle among friends, creating memories.
In my twenties, I enjoyed Italian wine quite a bit.

The second wine that captured my heart was an Australian wine my team leader
at work used to enjoy during my time as the youngest employee.
She described it as the scent of a garden soaked in morning dew. After work,
we'd sit on the terrace in the fancy bar and savor it with ricotta cheese and
honey-soaked apples. It was the taste of adulthood that always reminded me
of summer–white wine.

The last wine I cherished was a sophisticated and clean-tasting
Napa Valley wine. Perhaps it resembled the life I envisioned as I entered
my thirties. I have memories of losing track of time while tasting at a winery
and missing my flight.

Now, I can no longer enjoy alcohol as my alcohol metabolism has declined
to the point where I can only have an occasional glass of wine
when there are many people to share it with. Middle age may not allow me
to fully embrace the world of fine spirits, but I vividly recall the moments
captured in the aromas, flavors, and atmospheres of those glasses.

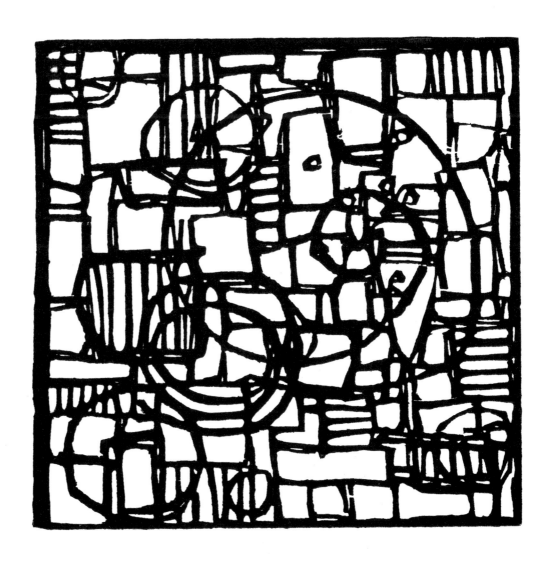

해

특별히 좋아하는 해가 있다.

저녁 무렵 커다랗게 지고 있는,

두 눈으로 바로 쳐다볼 수 있는 해.

서늘한 핑크빛이 도는 이때의 해는

납작하고 차가운 사탕 같아서

입에 넣으면 꼭 은은한 단맛이 날 것 같다.

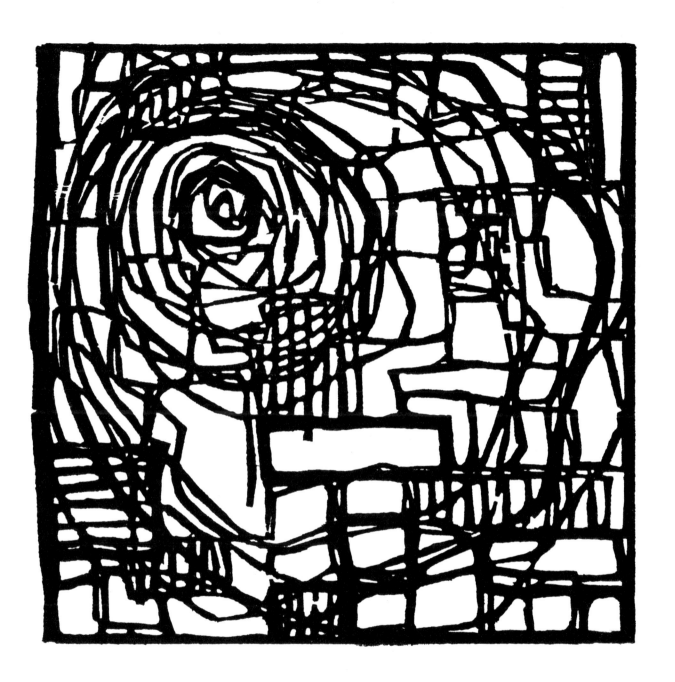

The Sun

There's a particular sun that I truly adore.

It's the one setting in the early evening, large and

prominent, the kind you can look at directly

with your two eyes.

During this time, the sun has a cool pinkish hue,

and it looks so flat and cold, like a candy that,

when you put it in your mouth,

would surely have a subtle, sweet taste.

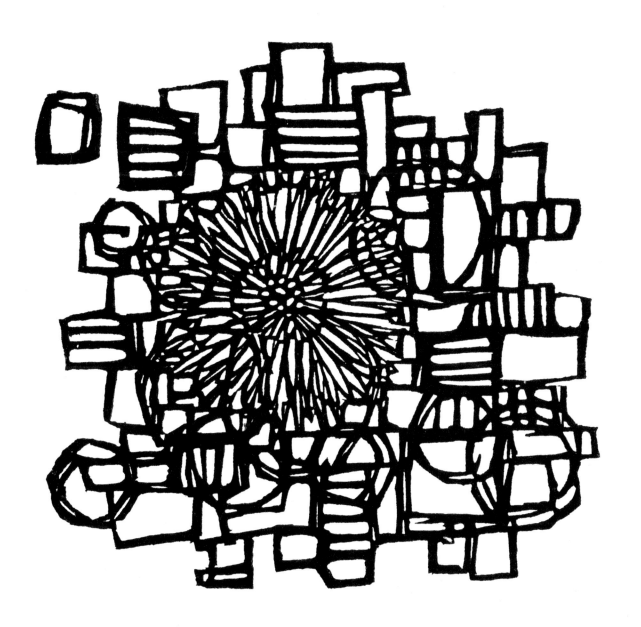

식물

생명이 번성하다 사라진 자리,

또 다른 종류의 생명들이 무성히 뒤덮은 광경을 상상한다.

뿌리와 균류와 초록이 뒤엉켜 만들어내는 압도적인 풍경을.

그림자와 빛은 더 강해지고, 포자와 풀벌레들이 날고 있겠지.

누군가 먹다 남은 파스타 접시에서 시작된 푸른 곰팡이와

내가 골머리를 앓으며 앉아 있던 책상과 아이맥을 뒤덮어버린 작은 풀꽃들.

바쁜 출근길 차가운 공기 속을 가르던 스타벅스 텀블러도,

누군가가 몇 대씩 사 모으던 고급 차량도 모두 덮어버린 초록을.

생명은 꺼지지 않고 영원히 꽃피울 것이다.

다만 우리가 사라질 뿐.

그 사실이 눈이 부시게 아름답다.

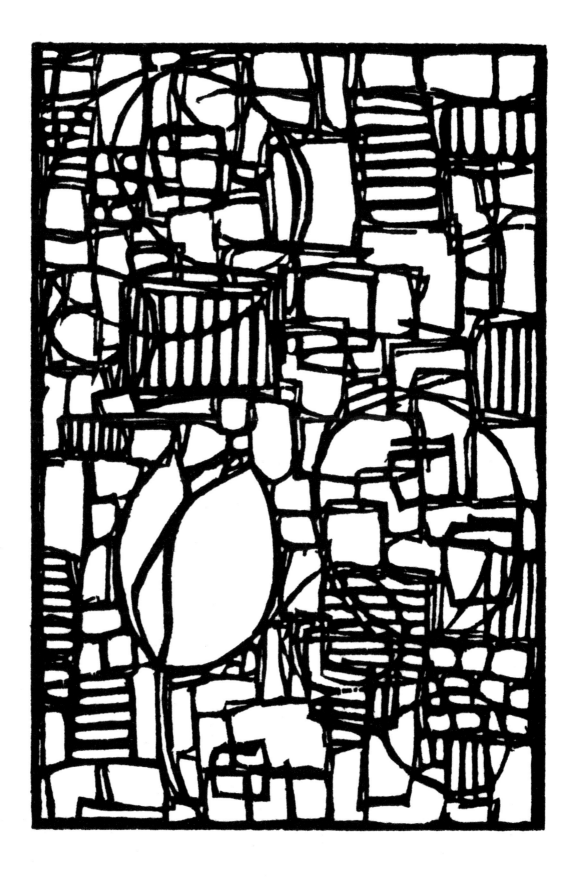

Plants

I imagine the scene where life flourishes and disappears,

replaced by another kind of life that densely covers the space.

An overwhelming landscape created by intertwined

roots, fungi, and greenery.

Shadows and light grow stronger, and spores and beetles take flight.

It all begins with the blue mold that started on someone's leftover pasta

plate and the small wildflowers that overtook my desk and iMac

as I struggled with my thoughts.

Even the Starbucks tumbler that once traversed the cold air

on busy commutes and the high-end cars that someone collected in

multiples are all covered by the greenery.

Life will never extinguish; it will forever bloom.

It's just us who will disappear.

That fact is dazzlingly beautiful.

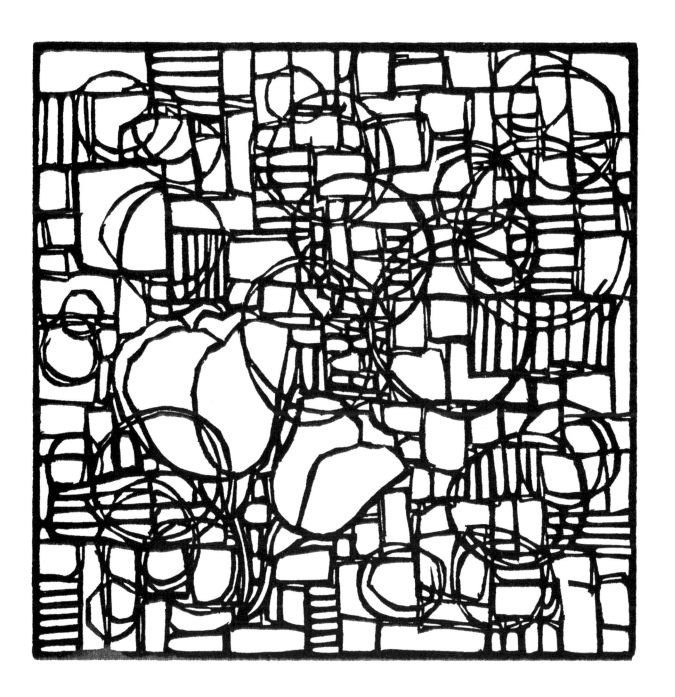

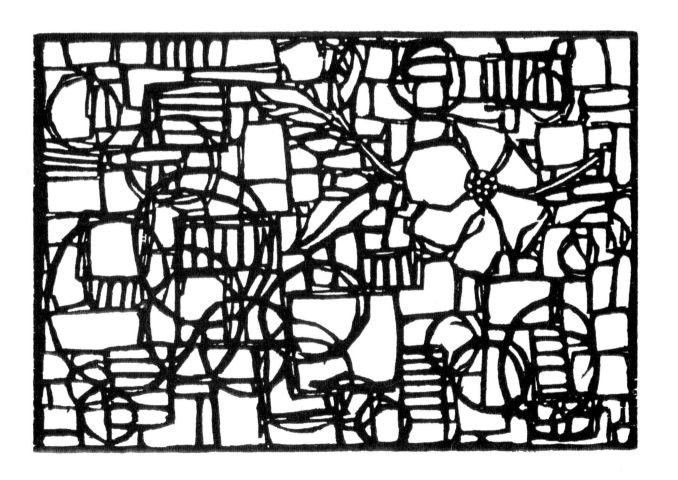

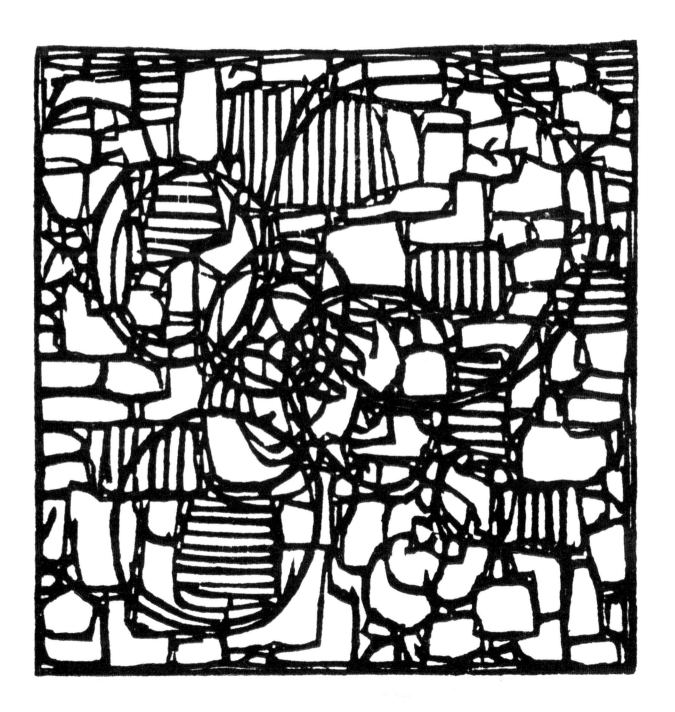

밤하늘

밤하늘 구름 사이로 먼 곳의 별빛이 보일 때
끝없이 광막한 우주가 느껴지고는 한다.

집 앞 편의점에 나갈 때도
꼭 한번 하늘을 올려다보며 별을 찾아본다.
순간 한없이 쓸쓸하고 작은 존재가 되는 것은
적잖은 위안이 되기 때문이다.
지구 표면에 다닥다닥 붙어 저마다의 삶을
아등바등 살아내는 사람들에게
왠지 모를 유대감이 피어오른다.
그들과 나의 삶을 어여삐 여기게 된다.

그러다 우주로 간 마음이 좀처럼
돌아오지 않을 때는
좋아하는 음식을 앞에 놓고
그거 한입에, 다시 땅으로 내려온다.

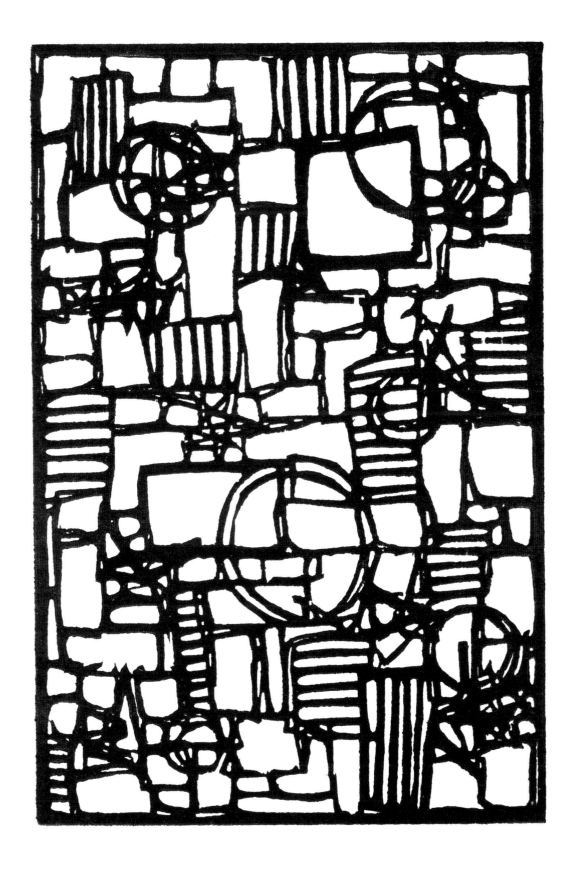

Night Sky

When I see distant starlight through the clouds in the night sky,
I can't help but feel the endless expanse of the universe.

Even when I step out to the convenience store in front of my house,
I always take a moment to look up at the sky and search for stars.
It offers some solace in the fleeting feeling of becoming
infinitely small and lonely in the grand scheme of things.
It somehow fosters an unexplainable sense of connection with the
people who struggle to live their own lives, side by side,
on the Earth's surface. I find myself feeling a kinship and compassion
with them, cherishing both their lives and mine.

And when my heart seems reluctant to return from
its journey to the cosmos, I place my favorite food in front of me,
take a bite, and find myself descending back to Earth
with each mouthful.

Hidden Pictures

숨겨진 장면들 / 컬러링 에세이

초판 1쇄 발행 2023년 10월 26일

지은이 / 김희진 박새롬
디자인 / 박새롬 스튜디오로움

펴낸이 / 전윤희
펴낸곳 / 메종인디아 트래블앤북스
　　　　서울시 서초구 방배로23길 31-43 1층

출판등록 2017년 5월 18일 제 2017-000100 호
ISBN 979-11-971353-7-8

Maison INDIA

여행을 예술처럼, 예술을 여행처럼 책으로 만듭니다.

Hidden Pictures

Coloring Essay

First edition, 1st printing published October 26, 2023

Author / Heejin Kim and Saerom Park
Design / Saerom Park Studio roam

Publisher / Yunhee Jeon
Published by / Maison India Travel & Books
1st floor, 31-43 Bangbae-ro 23-gil, Seocho-gu, Seoul

Publication registration May 18, 2017 No. 2017-000100
ISBN 979-11-971353-7-8

 Maison INDIA